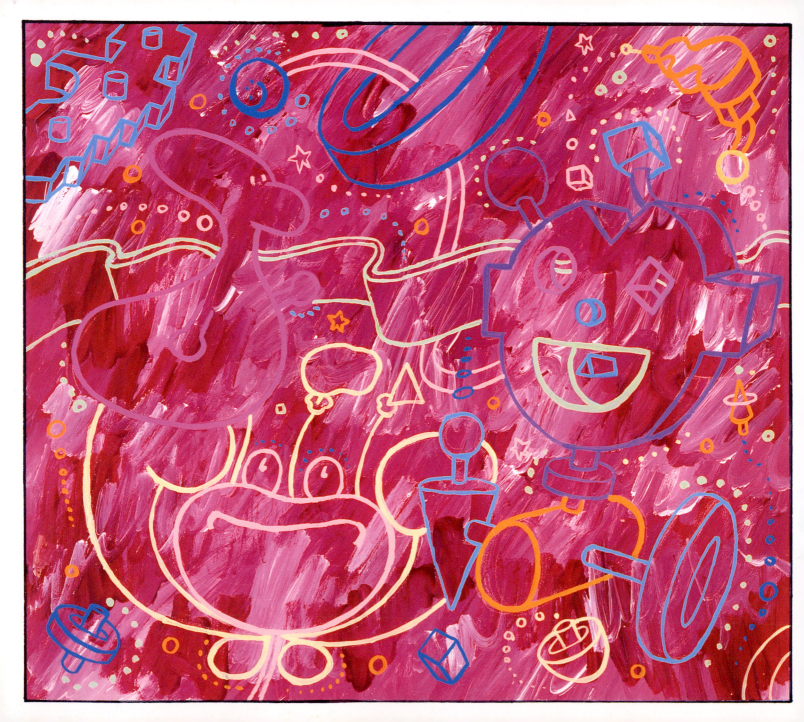

JAZZ FISH ZEN

ADVENTURES IN MAMBOLAND

BY HOWIE GREEN

CHARLES E. TUTTLE CO., INC.

BOSTON • RUTLAND, VERMONT • TOKYO

Special thanks to:

Debra Spark for her words and spirit,

Matthew Lashua for his haikus and humor,

Roberta and Peter and Linda for their encouragement and trust

and

Jeannie for making it all possible!

☞ Peace

Published by Charles E. Tuttle Company, Inc. of Rutland, Vermont & Tokyo, Japan, with editorial offices at 77 Central Street, Boston, Massachusetts 02109.
Illustrations © copyright 1992 by Howie Green Design
Mamboland, Jazz Fish, Mo'Rebo, Mr. Blockhead, Bonita Blockhead, Noodle, Power Flower and Turbohat © copyright 1992 Howie Green Design
Text © copyright 1992 by Charles E. Tuttle Company, Inc.

ISBN 0 8048 1800 2

First printed in 1992

Printed in Hong Kong

PEOPLE AND THINGS THAT HELPED ME LEARN TO MAMBO

In no particular order

Groucho Marx

Florence Ballard

Peter Max

Freddy Mercury

Mae West

Keith Haring

Bette Midler

Milton Glaser

Dick Tracy

Joan Baez

Ethel Merman

Peter, Paul and Mary

Mick's lips

Deitrich's eyes

River Phoenix

Garbo

Roy Rogers

Howdy Doody

Diana Vreeland

The Lone Ranger

Diane Von Furstenberg

Long Hair

Short Hair

Peter Noone

Luke Halpin

Andy Warhol

Ella Fitzgerald

Bob Conge

Knotty Pine

Boy George

Hudson Hornets

Mama Cass

'57 T-birds

Pissaro

Wes Wilson

Dr. Gideon Fell

Mouse and Kelley

Roger Daltry's fringe vest

Kathy Tuttle

Pee Wee Herman

Peggy Lee

Matthew Broderick

Palm trees

George Stavrinos

Victor Vasarely

Joseph Albers

Windsor McKay

Heintz Eidleman

Roger McGuinn

Huck Finn

Walt Disney

The Beatles

Norman Rockwell

The Hollywood sign

Aretha Franklin

Fred and Ginger

Victor Moscosso

W. C. Fields

Patti Labelle (Oh Girl!)

Freda Shapiro

Matt Dillon

Georgia O'Keefe

Suzie Parker

Sarah Vaughan

David Hockney

Indiana Jones

Vargas

Roger Rabbit

Maxfield Parrish

Fritz Trautman

Judy Garland

James McMullen

Margret Woodbury Strong

Mel Brooks

Tail O' the Pup

Smitty and Archie

Maurice Sendak

Emmy Lou Harris

Millie the Model

Tina Turner

Rick Griffin

Venice Beach

Carmen Miranda

Arthur C. Clarke

Janis Joplin

Antonio Lopez

Tim...and Chris

INTRODUCTION

I'd like to claim credit for inventing the Jazz Fish. He has gotten more response from people than anything else I've ever done and he did come from my pen. But, I think he was a gift from the muses... let me explain.

I was on the phone with a client a few years back and I was doodling rather unconsciously while we spoke. I looked down at my note pad and there was the Jazz Fish fully realized in all his funky glory. I showed it to my assistant who asked where "*that*" came from and I honestly stated "I don't know, I just drew it."

A short time later I saw the movie *Always*, a sweet Spielberg epic about a flyer who dies, but whose spirit has to stick around because he hasn't released himself from earthly ties or some such thing. The flyer inhabits a separate but parallel reality to our earthly plane. While he can't directly interact with anyone he can sneak into their thoughts and make suggestions to their subconscious or unconscious minds. And he can be a bit of a pest and mess things up.

The concept of two co-existing levels of reality hit me as a rather good explanation for a lot of serendipitous things in life.

Like: why things constantly disappear and then reappear from my desk top. Or where something as unusual and wonderful as the Jazz Fish came from.

This book is also about two levels of reality that co-exist – the physical reality of the land of Mambo and the spiritual reality of the Jazz Fish's Mambo.

In this story Jazz Fish takes various influences and things from the land of Mambo and builds something new that never existed before. While he builds his structure he is also building his spiritual Mambo. This is something we all do with our lives. We all take bits and pieces and build a new whole. Whether it's something physical like a piece of art or something more intangible like a friendship, we all create around us a reality that only exists because we are there to make it happen. And, because we created it, we are forever changed in the process.

As you follow Jazz Fish while he builds his Mambo I hope you think about what you have taken from life, what you have created with it, and how the process changed you.

I thank the muses for their gift to me of the Jazz Fish. He is a fabulous addition to my life's Mambo.

Howie Green

CAST OF CHARACTERS

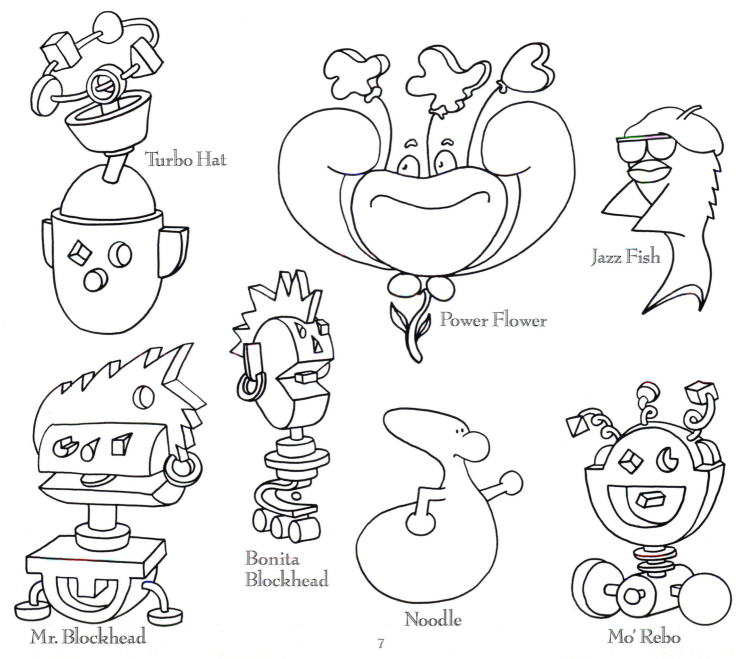

Turbo Hat

Power Flower

Jazz Fish

Mr. Blockhead

Bonita Blockhead

Noodle

Mo' Rebo

7

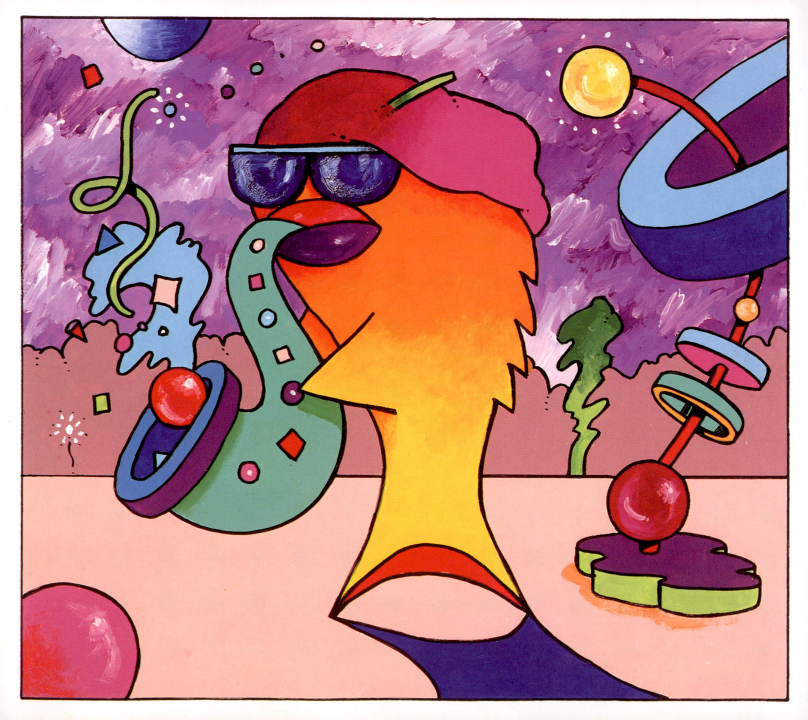

Maybe he was saddened by private griefs, too numerous to mention, or maybe he was in flight from an embarrassing past, or maybe he was just looking for something…the way one does…and started to wander foreign lands. Whatever the reason was, the Jazz Fish came to the gate of Mamboland. He peeked in and thought about what he should do next.

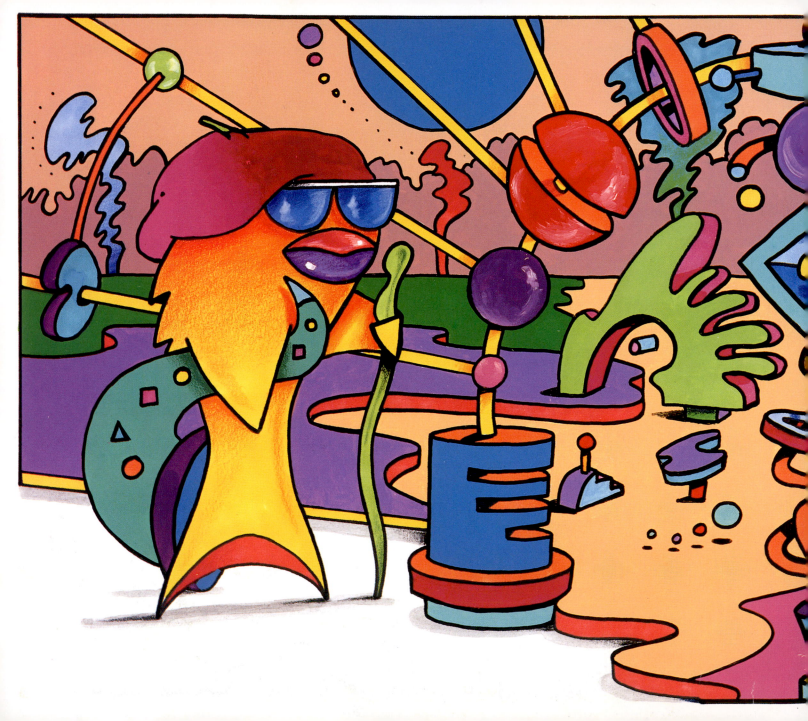

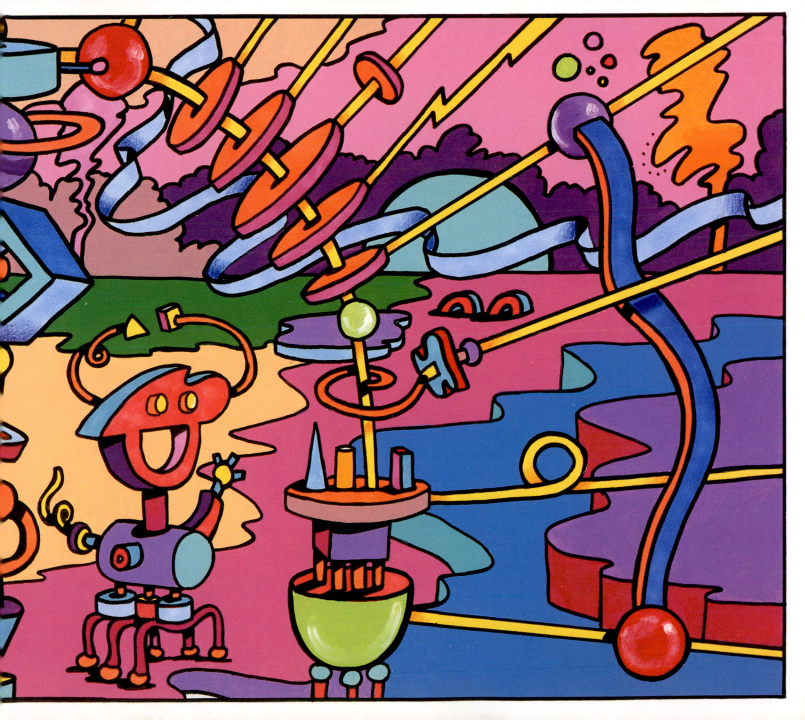

From what he could see from the gate, Mamboland was nothing like anyplace he had ever been. First of all, Jazz Fish could find little of himself or his old world there. Despite the name of the place, Mamboland seemed to have nothing to do with a Latin beat, instrumentals, or dancing. Here, the fish told himself, his old sense of words would not apply.

But that wasn't all. The place, in every aspect, was different, less readable, and more abstract than the spots that Jazz Fish had previously visited. The rules of gravity were haphazardly applied. Sometimes things floated; sometimes things stuck to a plane that was, itself, mysteriously suspended in space; and sometimes things seemed to do both at once.

Creatures were changeable, too. Jazz Fish saw a smiling box affix itself to something that looked like a mechanical crab, and a whole new creature was born. How was Jazz Fish to make sense of personal identity in a land like this? It didn't matter, Jazz Fish concluded, for a place like this could be conducive to thought. Here, Jazz Fish hoped, he would be able to calm himself, calm his own passions so he could find out what was real and true.

Jazz Fish decided to go through the gate and begin his adventure.

His first day in Mamboland, Jazz Fish didn't say hello to anyone. This wasn't conceit or shyness. He was trying to observe, to refrain from being a participant, so he could learn. Jazz Fish had his reasons; the one thing that the Jazz Fish understood, had always understood, about himself, was that he lacked understanding. And, when he asked himself, out of concern for himself, to be more specific, he found that he couldn't be. He just understood that he didn't understand.

Not that the Jazz Fish did not *know* some things. For instance, he knew he was a fish with a human consciousness and therein lay his dilemma. It wasn't a social problem (i.e., whom to spend time with—fish or people?). It wasn't existential (i.e., was he a fish who talked? a man dressed as a fish? or some other mysterious thing?). It wasn't psychological. He didn't wonder who he was, because he knew he was a fish with a slouchy beret, a saxophone, and prominent lips. (Some, he knew, thought he feigned a sort of Cool Cat attitude, a be-bop hipster manner, but he knew this wasn't fair. What self-respecting fish would pretend to be a cat? As for his manner, he couldn't help it, he was, as a friend of his had once said of herself, just drawn that way). The problem, as he saw it, was metaphysical. What was the world and how should he place himself in the world?

If the answer to the question was in Mamboland, Jazz Fish would have to quiet himself. He knew that you couldn't learn anything if your own mouth was moving.

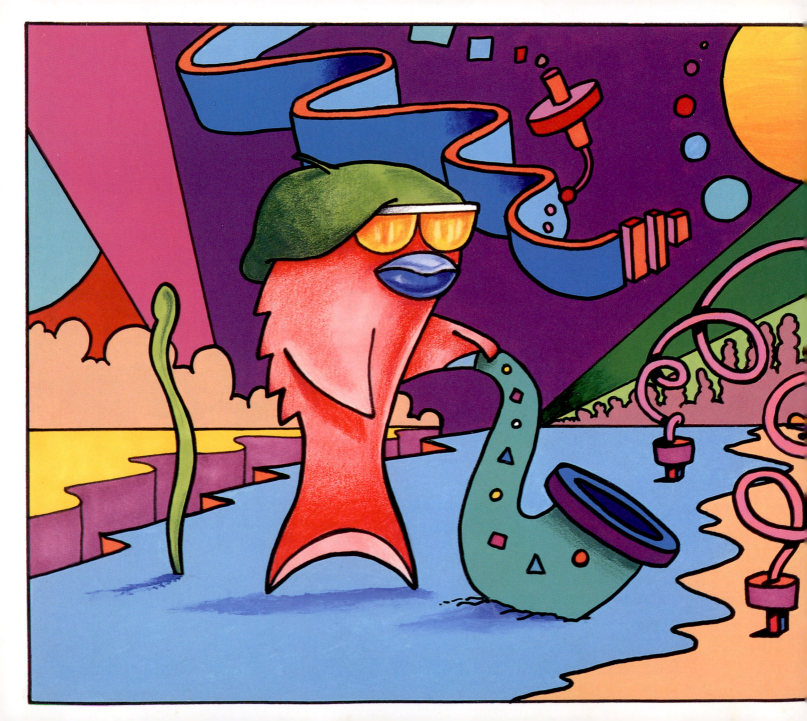

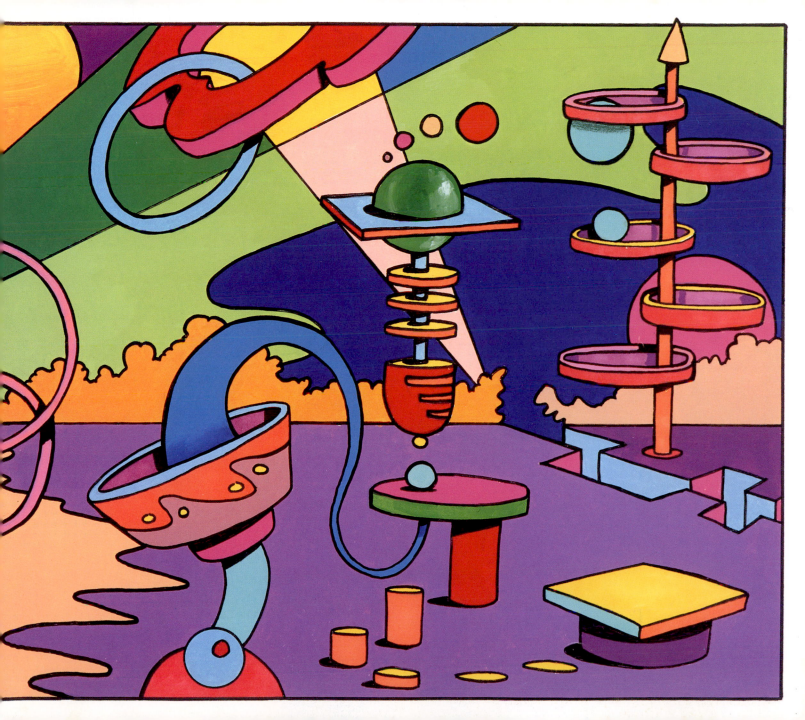

NATURE UNINHIBITED

BY PERCEPTION. WELCOME TO

MAMBOLAND.

So, Jazz Fish watched. He watched the sky turn bubblegum pink and then grasshopper green. He saw walls that roamed, like water snakes, through the sky.

And as he watched, he was watched, from across a wide plane, by a rubbery white creature named Noodle and his good friend Mo'Rebo. The two were about to take their daily tour of the planes.

They were an odd pair. Noodle, for one, suffered delusions. He considered himself mayor of Mamboland, although no one else did. Still, he had convinced the endlessly sympathetic Mo'Rebo to play his sidekick. Mo'Rebo, in turn, was struggling to overcome his own delusions. He was trying to see things for what they were. He was trying to see that all things were one thing, that you couldn't make distinctions (for all distinctions were false) between good and evil, or black and white, or anything else. The problem for Mo'Rebo was that he still felt the worldly passions; he still hated hate and he could not overcome love. And, he couldn't understand why he should overcome love or if, for some reason, he had so misunderstood things that he was mistaken in even thinking he should overcome love.

Mo'Rebo didn't know if it was right or wrong—or if right and wrong were false notions—but still he stayed loyally beside Noodle, because he cared deeply for him and wanted to make sure Noodle wasn't hurt by his own foolishness.

"Do you think," said Noodle, "we should invite him onto the planes?" He was referring, of course, to the Jazz Fish.

"I don't know," said Mo'Rebo. "It doesn't look like he wants company."

Noodle seemed not to have heard Mo'Rebo, for he continued the same line of questioning, "Should we invite him out on the planes, out to tour the crops, out to get a lay of the land?" Noodle said.

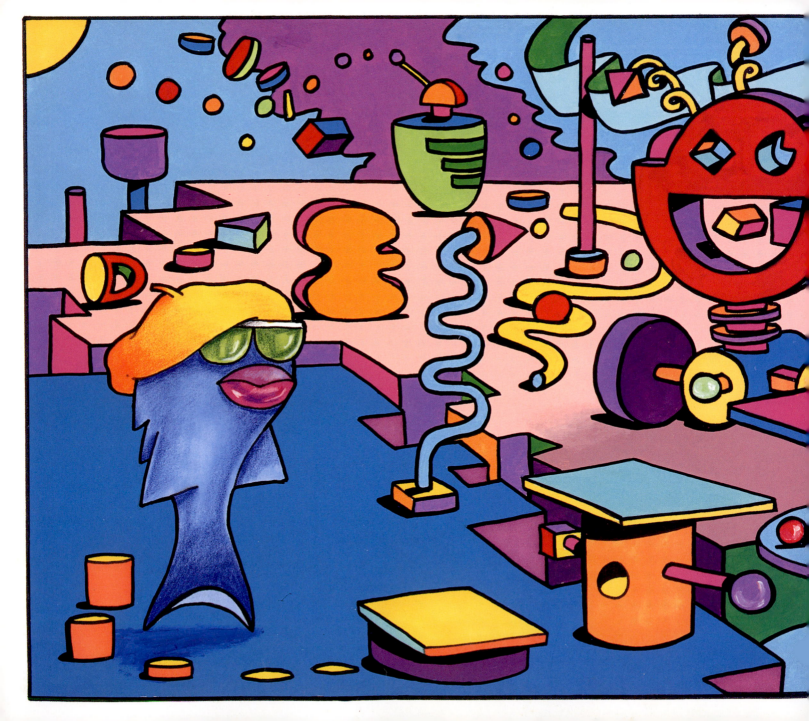

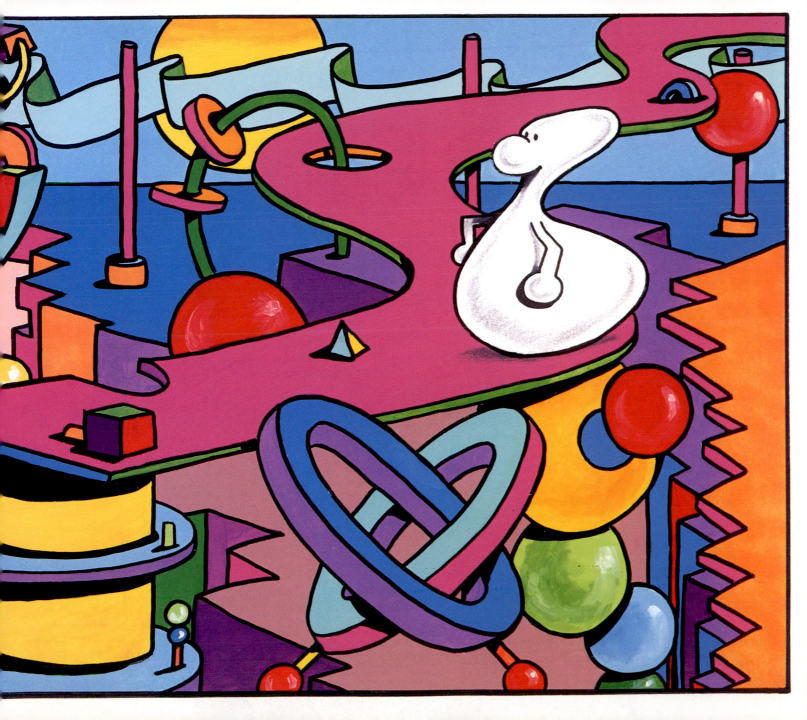

EFFICACIOUS TRANSPORTATION:

GLIDING ON SLIDES OF CONSTRUCTED COLOR

RASPBERRY RED, UNFLAPPABLE BLUE

For days, Jazz Fish stood silently, observing. A plane stretched before him and, at the far end of the plane, was a white duck. Or something that looked like a white duck made out of putty, but that wasn't quite right. *Forget,* Jazz Fish told himself, *the urge to representation. Things aren't ducks or putty. They just are.*

Though this new landscape was not, initially, familiar to Jazz Fish, eventually, he began to see points of connection. The colors of Mamboland were colors that Jazz Fish recognized. He knew those shades of orange and pink and red and yellow and midnight purple. The sky in Mamboland changed colors at will, and Jazz Fish, too, was blue one day, orange the next. The forms, too, though oddly assembled, weren't that odd to him. He knew squiggly lines and circles and curves. For what was he if not those shapes? His belly was a curve, his back fins a squiggle.

Jazz Fish decided to start to build something—something like a thought with no content but with color and form. After all, he understood the colors and forms of Mamboland. But the content of it? He had no names for that funny looking mechanical face with a column for a tongue. So, Jazz Fish started with a color and let it take form. He allowed himself a purple squiggle.

Did he know what he was doing?

He did not, but that didn't seem to matter. He would just build...oh, what to call it...he would build his own Mambo. One that had something to do with Mamboland—included pieces of it after all—and had nothing to do with the Jazz Fish's old sense of Mambo. He added a blue disk to his purple squiggle. Maybe this would mean something when he was through, maybe not. He wouldn't worry about that. He attached a cone and sphere to his Mambo.

Then, he blinked. And everything changed. He saw odd and gigantic things. He wanted to say, "Flowers," but he wouldn't let himself.

With another blink, they'd look like something else anyway.

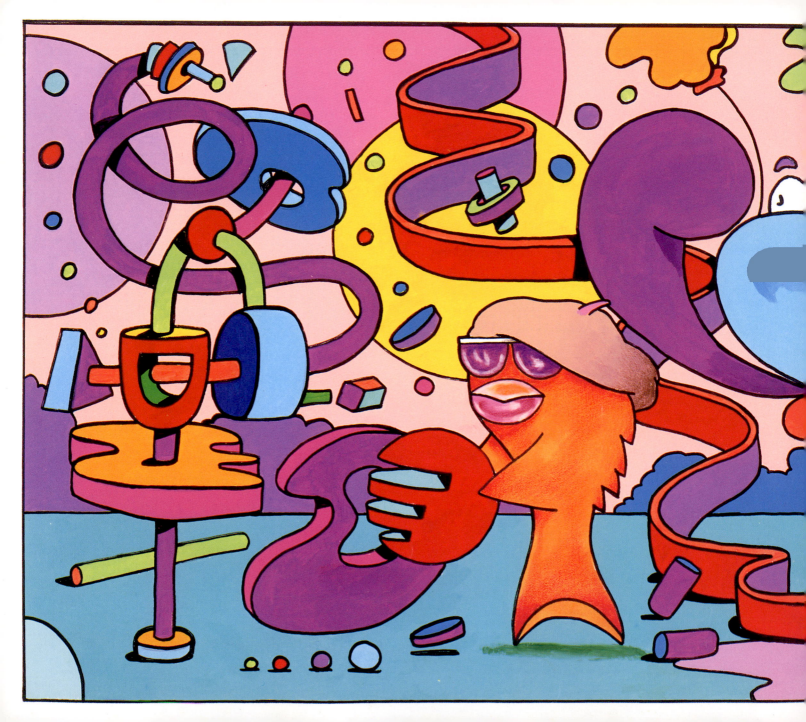

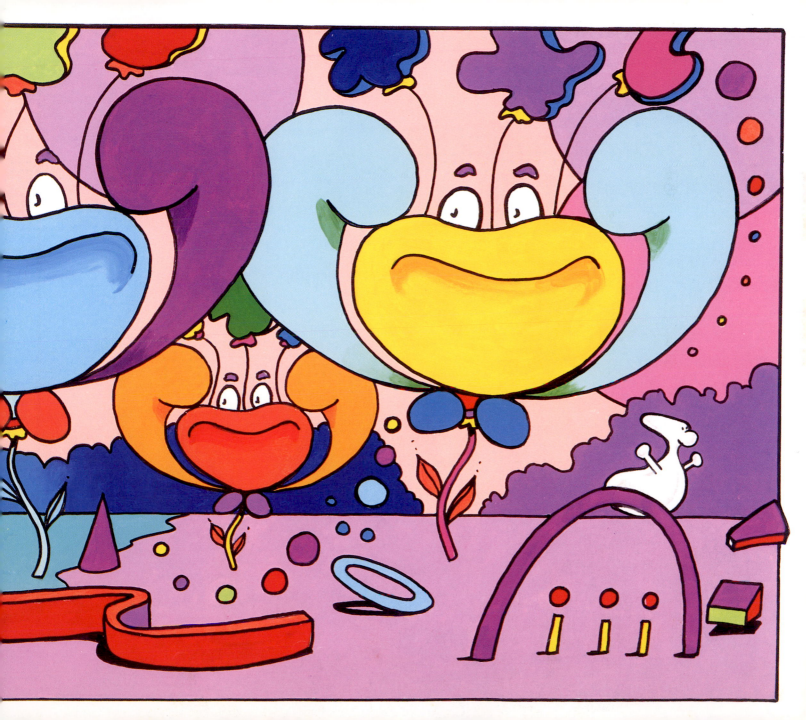

IT'S A CURIOUS CRITICISM,

THEY MISUNDER STARE.

FLUFFY FLOWERS

Jazz Fish stayed so long in Mamboland that days and nights ceased to have real meaning for him. Without a sunset, who knew when a day was over? Without a watch, the passing of time seemed confusing. Minutes stretched endlessly, but Jazz Fish felt like he had just arrived in Mamboland. He was aware of creatures watching him. Sometimes with consideration. Sometimes with the kind of confusion that borders on anger.

"What are you doing?" the Blockheads asked him.

"Say!" demanded Mr. Blockhead.

But Jazz Fish couldn't say, although forms and colors, all still without content, were blooming in his head. He thought, sometimes, of his old interest in music, in jazz. He was doing a visual riff, he thought. But, then, that wasn't quite right since his Mambo wasn't purely visual. His Mambo wasn't about the senses.

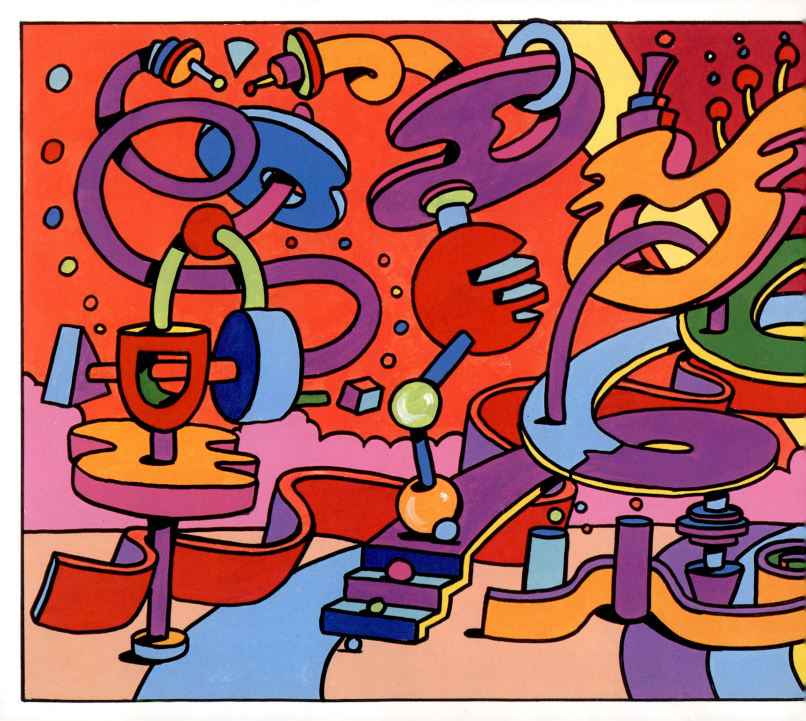

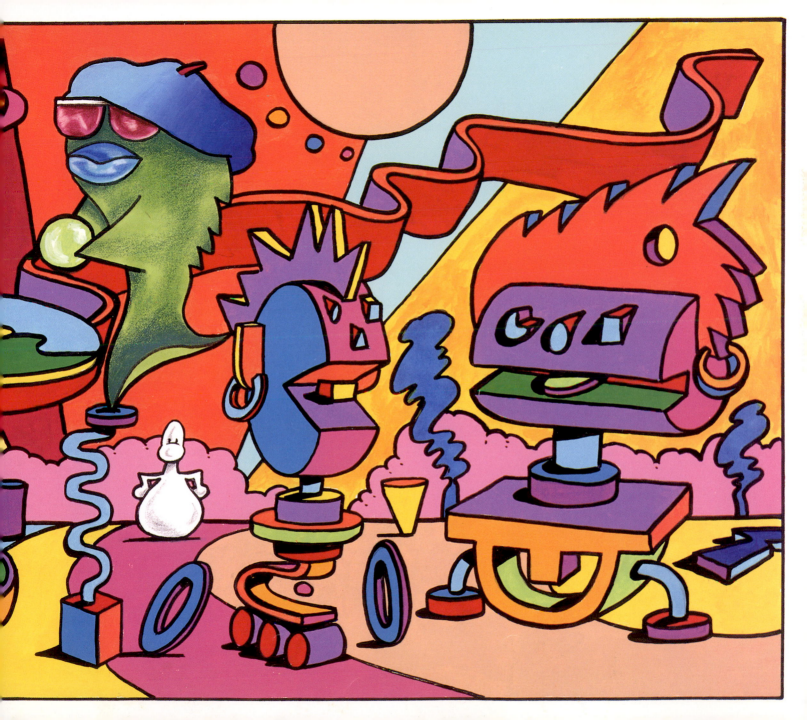

BLOCKHEAD TO BLOCKHEAD:

"I SUFFER FROM

INTERPRETATION HALLUCINATION."

Once, a figure that looked a lot like Noodle appeared in Jazz Fish's Mambo. It was white and putty-like and had a funny nose and black eyes like pin points. It appeared but was so obviously wrong, Jazz Fish took it out of his Mambo.

This isn't to say that Noodle suddenly disappeared from Mamboland, only to appear in Jazz Fish's Mambo. For if he had, Mo'Rebo would have tried to venture out of Mamboland and into Jazz Fish's Mambo to retrieve Noodle. And what sense is there in retrieving something from a thought?

Once he rejected Noodle, Jazz Fish seemed to have a stronger sense of what he was doing. He began to add more and more colors and shapes. He seemed to be picking items for his Mambo with a new certainty.

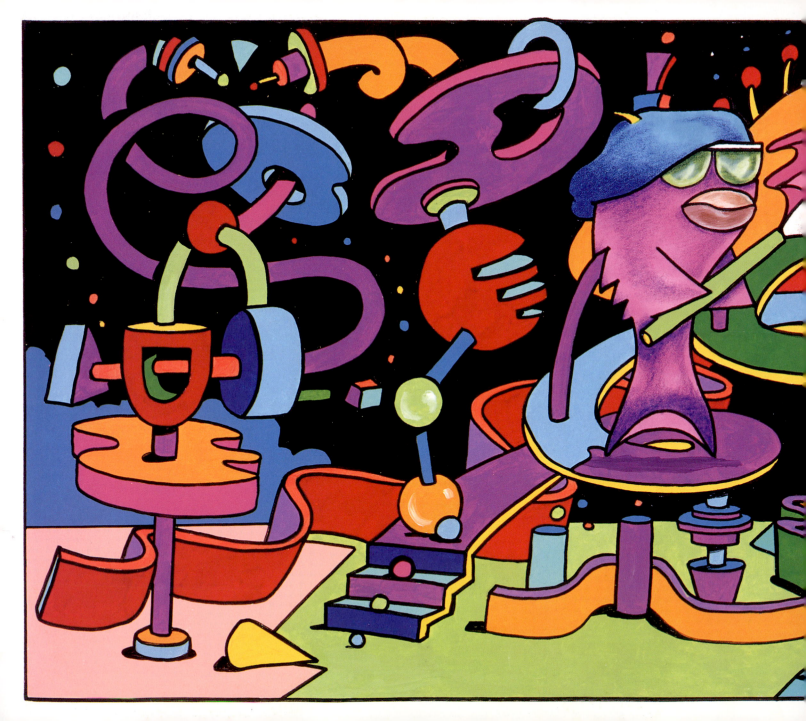

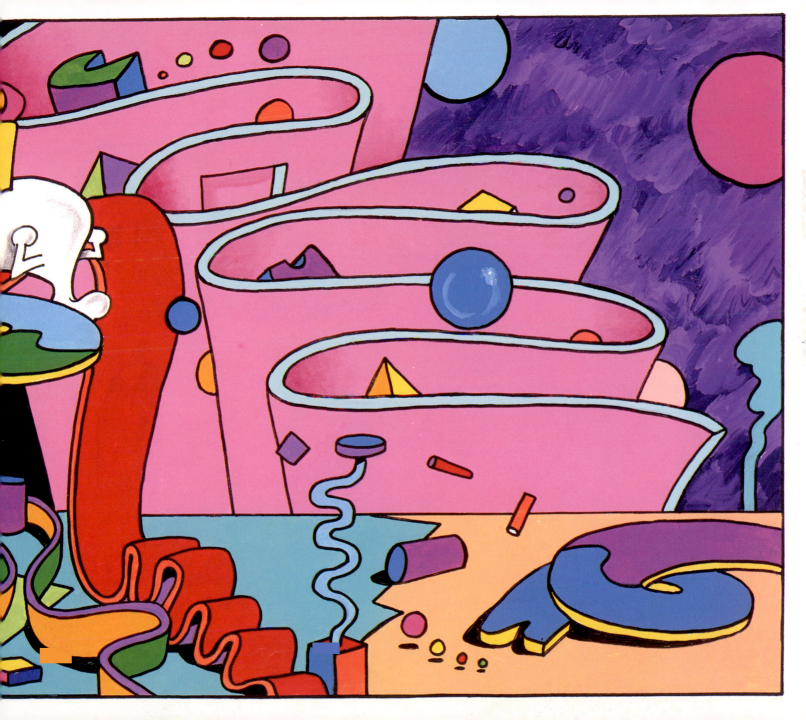

COMPOSITIONS NOT COMPLYING:

REVERE, CELEBRATE,

THROW AWAY.

Finally, Jazz Fish had a sense of completion. He had selected elements from Mamboland and composed something—something with form and color but without content—and it was his own, his own Mambo. The fish felt like he was nearing truth. The process had been gradual, but he was on the edge of getting there. He added more and more; he confidently subtracted a squiggle and substituted a column for a cone.

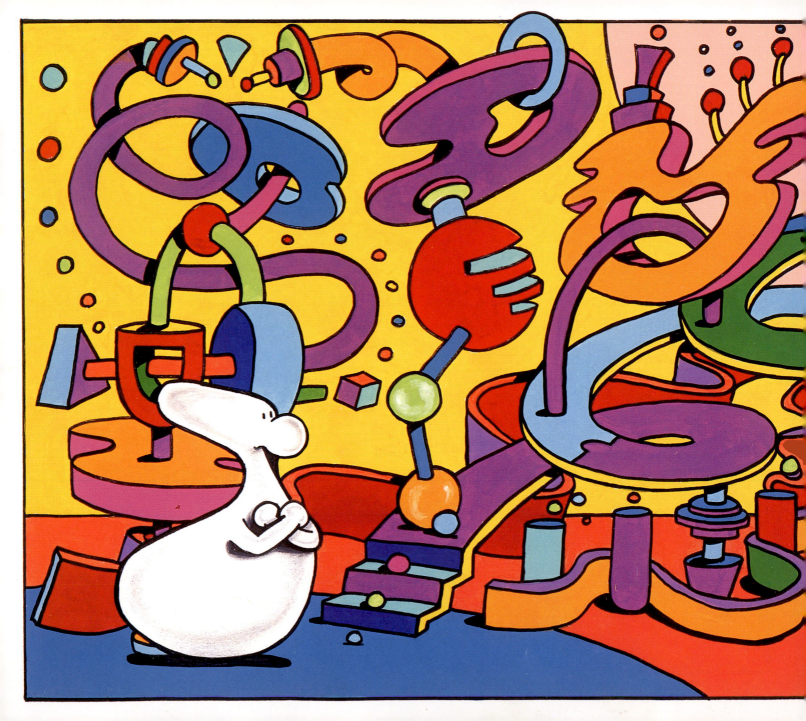

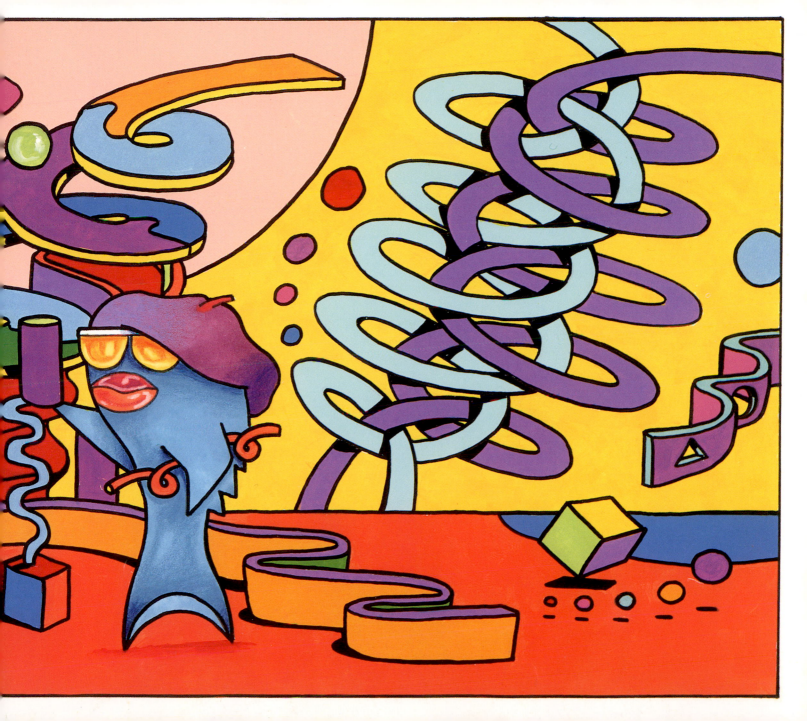

THERE IS MERCURY IN MY HAT:TURBOHAT.

SWIFT STREAMLINED EFFICIENCY

SIZED SIX AND SEVEN EIGHTS.

Then, there was something like a crack in his Mambo, and at the same time—
and this for the very first time—there was a similar crack in Mamboland. It was as
if the curtain of Mamboland was pulled back for a second and then, out from
backstage, a creature wearing an unusual hat appeared.

"Turbohat!," Noodle shouted.

"It's him," said Mo'Rebo, and the citizens of Mamboland—The Blockheads and
Power Flowers —nodded their heads in agreement.

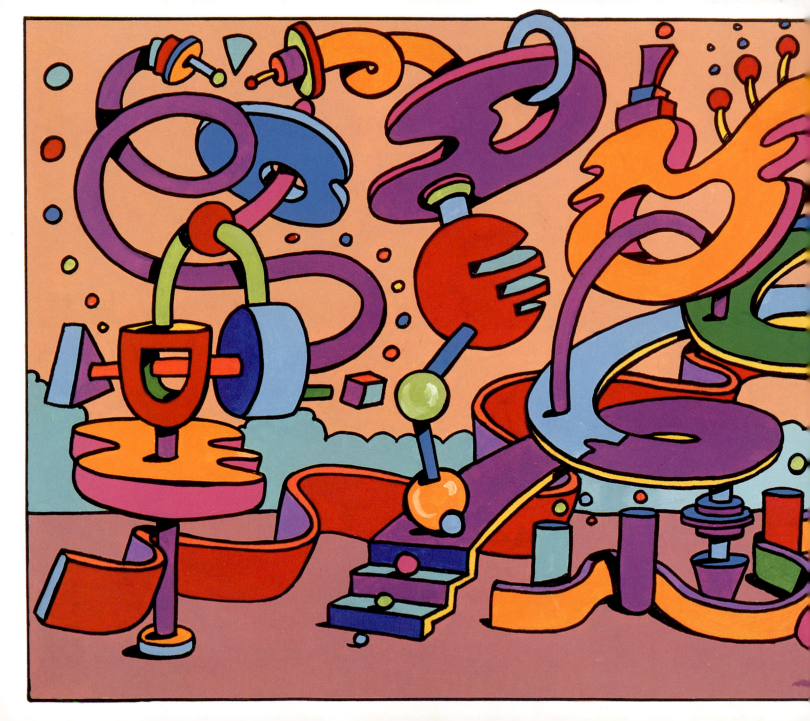

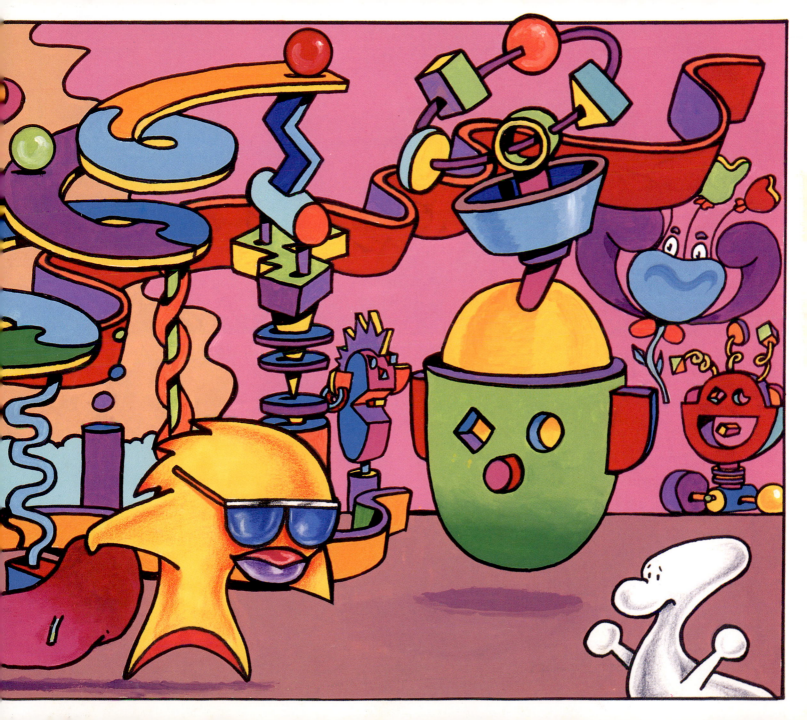

The Turbohat asked Jazz Fish the very same question the citizens of Mamboland had asked so many days ago. "What are you doing?" he said, although the question seemed, oddly, more profound out of the Hat's mouth.

"He's making a Mambo," Noodle said. "It's very lovely, wouldn't you say?" Noodle asked the Hat.

"And where is the builder of this Mambo?" said Turbohat. The question made no sense to anyone, but Mo'Rebo said, "What do you mean? Are you asking about the Jazz Fish? The Jazz Fish right here in Mamboland?"

"And where is that?" a Blockhead asked.

Mo'Rebo and Noodle were confused. What was everyone talking about?

"Mo'Rebo!" thundered Turbohat, as if to demand that Mo'Rebo answer the question.

Mo'Rebo looked beseechingly at Turbohat. He couldn't guess what the Hat wanted from him.

"And where is that?" Turbohat repeated.

Mo'Rebo stared and said nothing, but, all of a sudden, Jazz Fish's Mambo was replaced by emptiness. The Jazz Fish grasped the point and bowed. Even though Jazz Fish's Mambo was gone, it was completely whole.

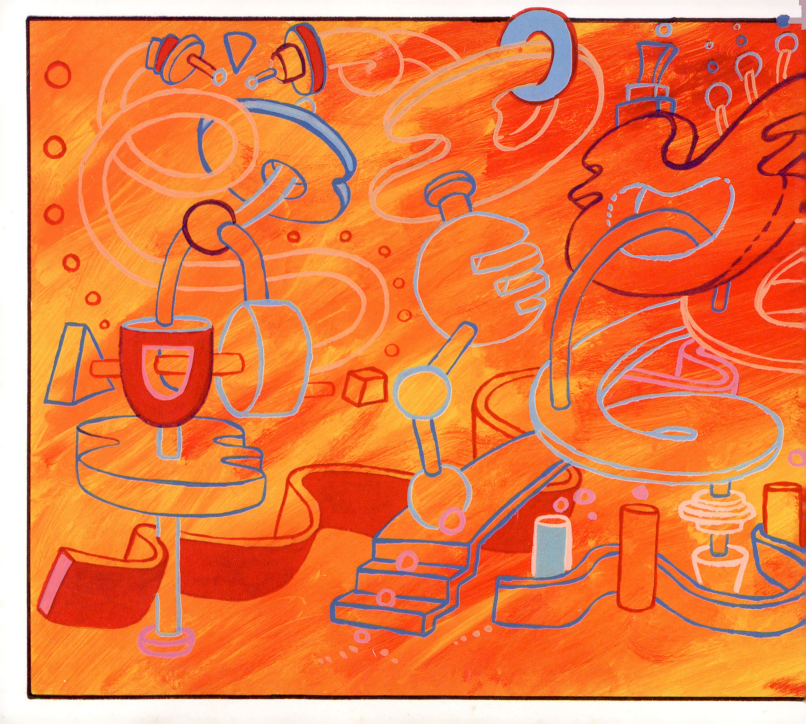

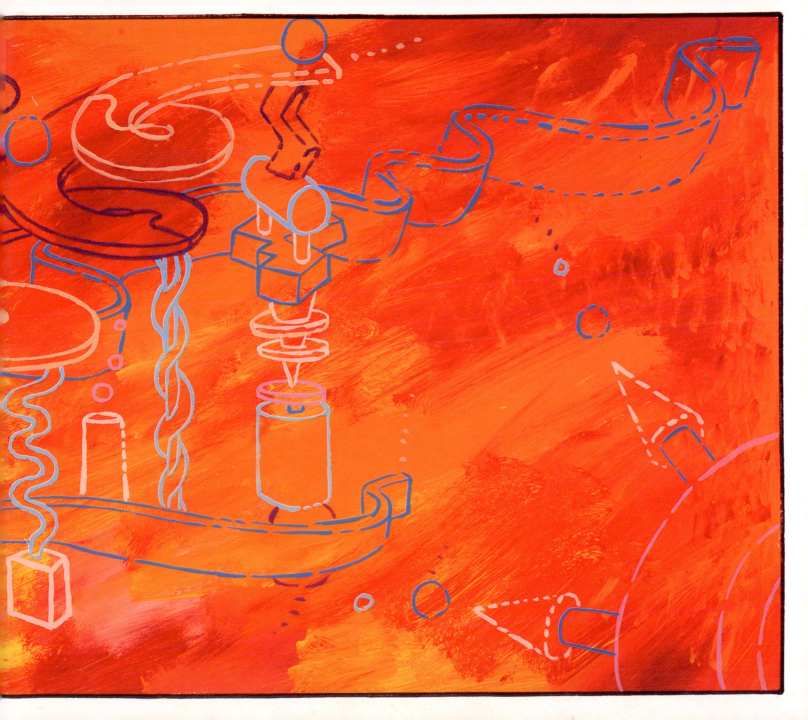

What did Jazz Fish grasp?

Did Mo'Rebo grasp the same thing?

Why did Mo'Rebo say nothing?

Why did the Fish bow?